CITIZEN USA

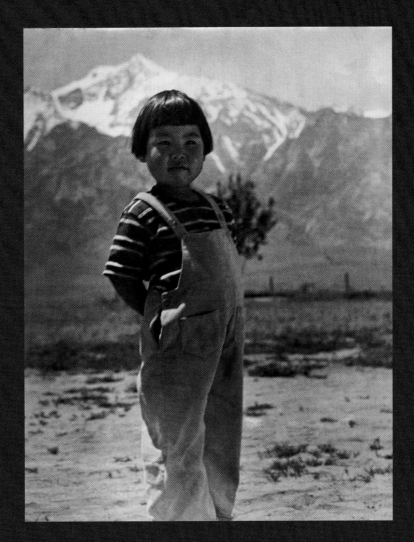

CHARLES K. FERGUSON

Published in cooperation with **janm** ⬦ JAPANESE AMERICAN NATIONAL MUSEUM

APPLEWOOD BOOKS

Carlisle, Massachusetts

All photos by Alan Hennebold

Copyright © 2020 The Japanese American National Museum

978-1-4290-9556-3

Published by Applewood Books

To request a free copy of our current catalog
featuring our best-selling books, write to:
Applewood Books
P.O. Box 27
Carlisle, MA 01741
Or visit us on the web at: www.awb.com
Book design by Sheila Smallwood

Printed in China

10 9 8 7 6 5 4 3 2 1

INTRODUCTION

Imagine you're a child—born and raised in the United States—and you suddenly find yourself and your family wrested from your home, taken to a desert far away, and made to live in tarpapered barracks behind barbed wire for who knows how long. You don't have a kitchen or even a bathroom. You still salute the flag every day. Yet as young as you are, you know this isn't your America. This is the story that this humble, short book conveys. Deceptively simple but remarkably profound, it is a fictional portrayal of the realities of Manzanar, one of ten American concentration camps where Japanese Americans were held during World War II. This publication of *Citizen USA* comes from an artifact in the permanent collection of the Japanese American National Museum. It was compiled and written in 1942 by Charles K. Ferguson, known as Chuck, while he was director of adult education at Manzanar. It is the first known book told from a child's perspective about the wholesale imprisonment of 120,000 innocent Japanese American men, women, and children by the United States government during World War II.

The original manuscript consists of eleven loose, double-sided pages of now slightly torn and tattered black construction paper. On each side are black-and-white photographs with handwritten captions in white lettering made to look like a child's printing. Markings in pencil indicate that the original artifact was a draft. While this publication has been updated to reflect what the finished book might have looked like, the images and captions have been left unedited and retain the original language from the time it was written.

CITIZEN USA

I am Jane Sato. I was born in Hollywood, California.

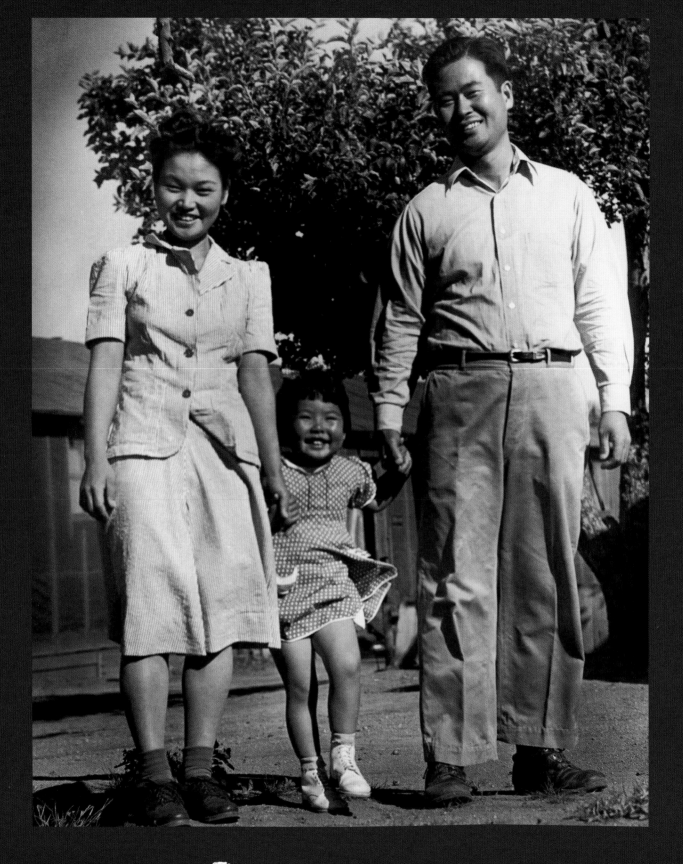

These are my parents.
My father's name is Elbert Sato.
My mother's name is Mary Sato.
Mommy was born and raised in Hollywood too.

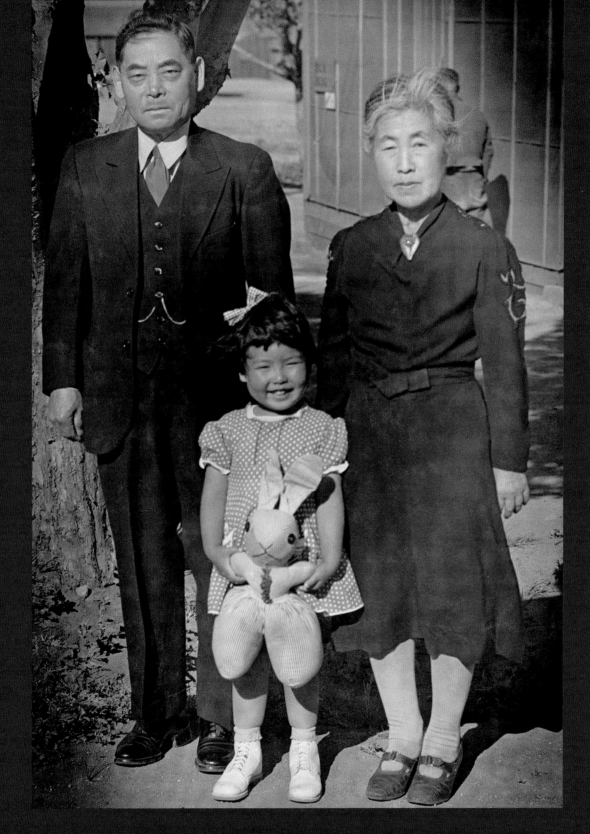

These are my grandparents, Frank and Taki.
They came to America 13 years ago.
They came because they wanted to be free
and have a chance to live better.

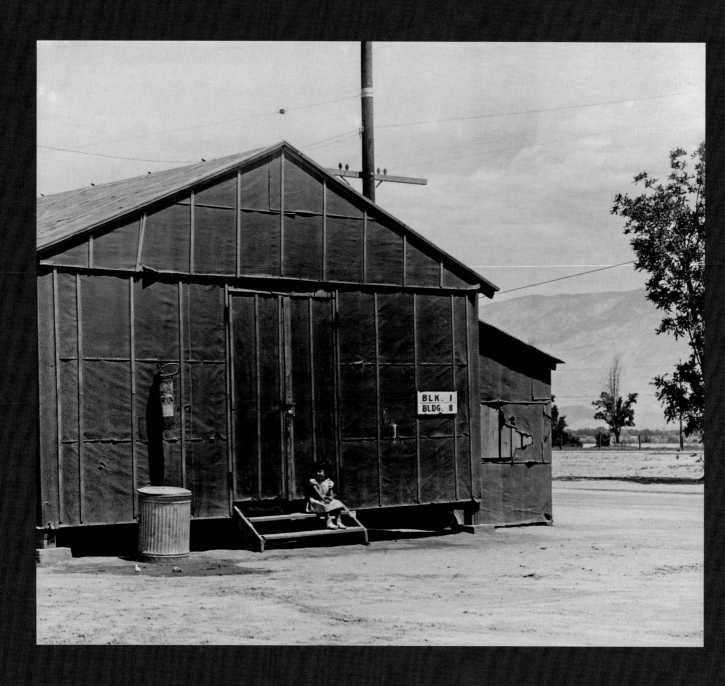

Over a year ago the army took us away from our house in Hollywood and brought us to Manzanar away off in the desert. This is my house.

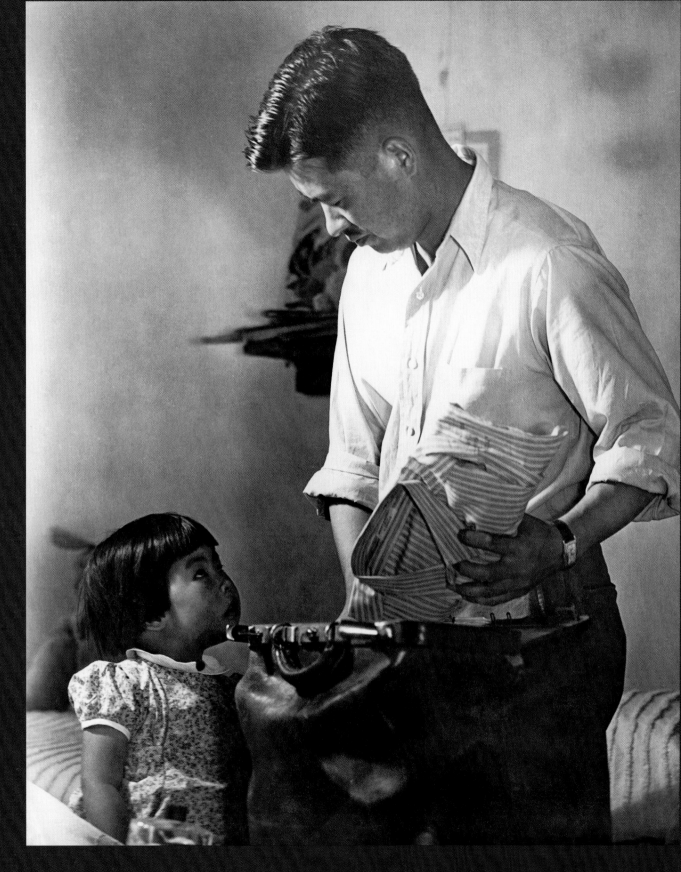

My daddy says we could leave here and go to Chicago
or Cleveland or someplace if he can find a job.
Then he will bring us out with him.

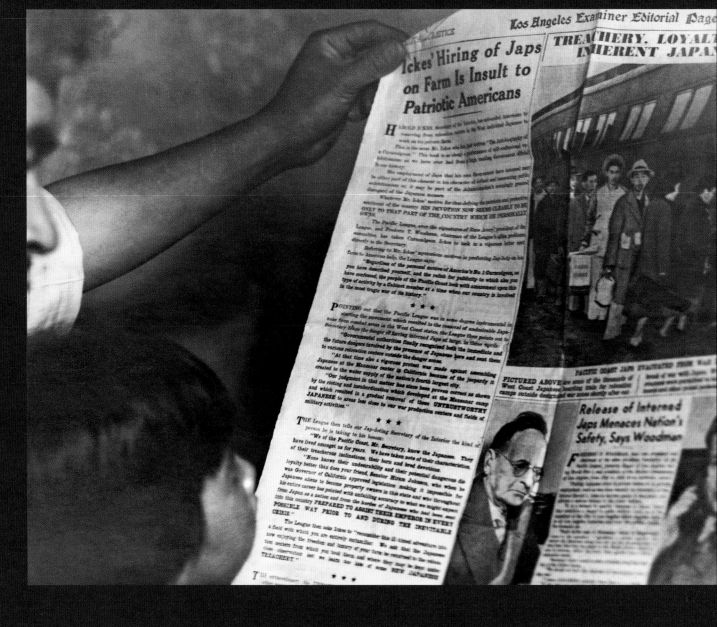

The paper says we are an insult to America, but we are Americans too.

Why am I an insult?

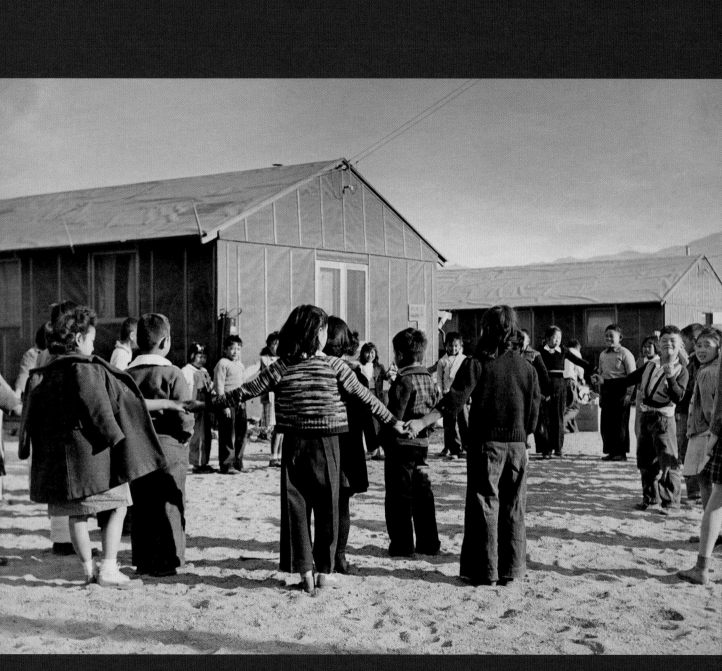

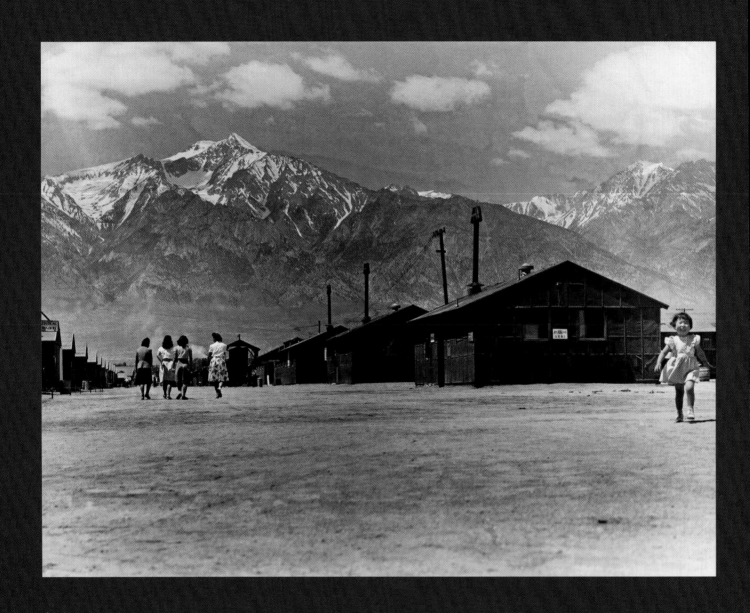

The mountains are pretty here,
but it's awfully hot and dusty.
We have dust storms every week and
it's so dry my skin is chapped all the time.

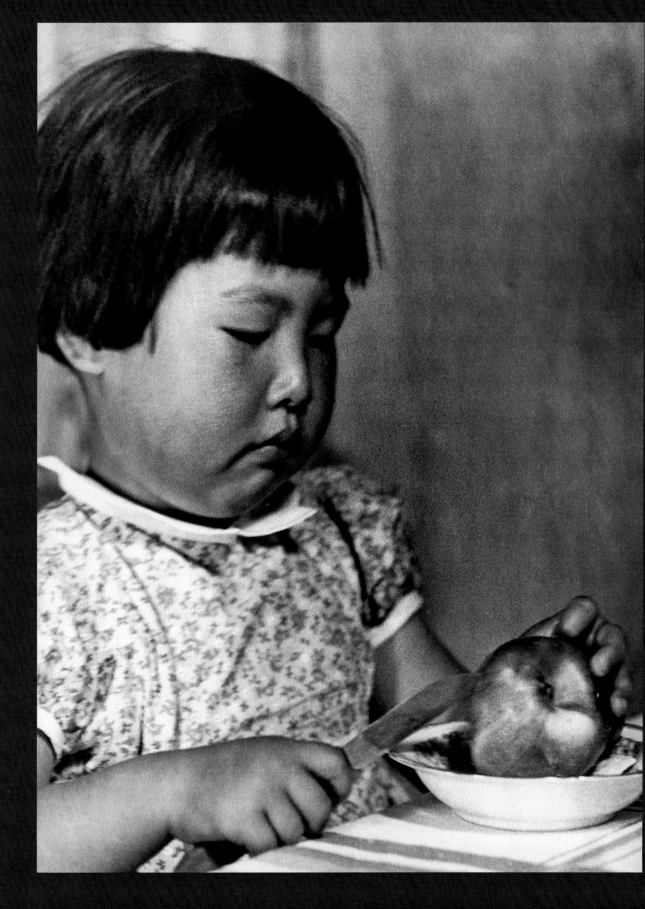

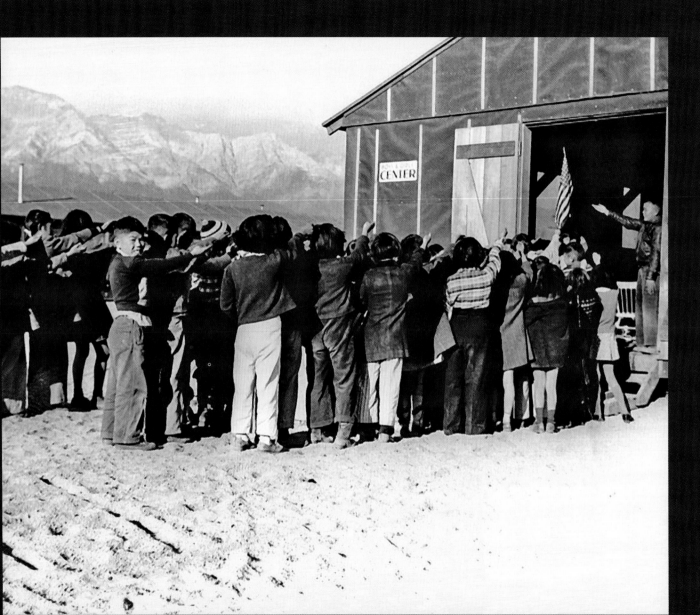

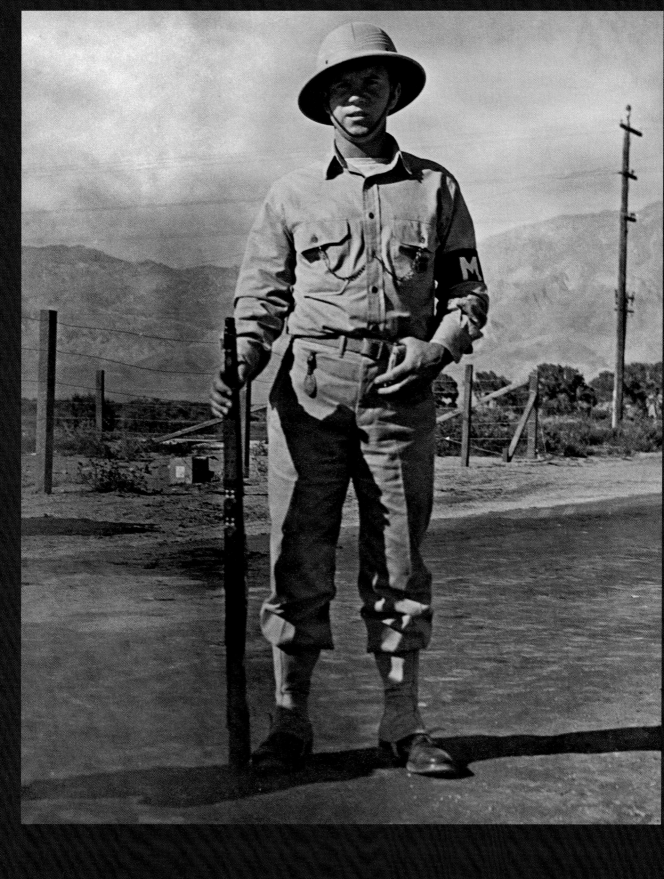

I'd like to see the airplanes across the road,
but I can't because the soldier won't let me go
past the fence.

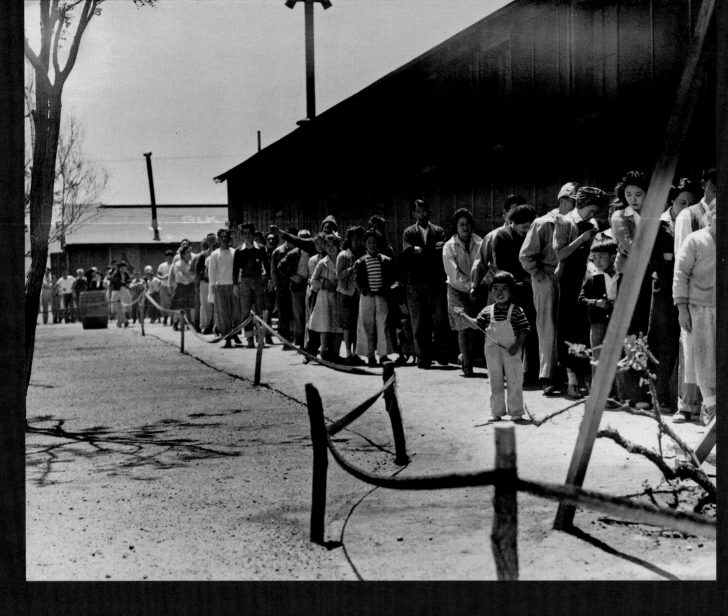

At home in Hollywood I used to watch my mommy bake and cook, and I could help her get dinner, but here we have to wait in a long line before we get to eat. Everybody in our block eats in the same mess hall.

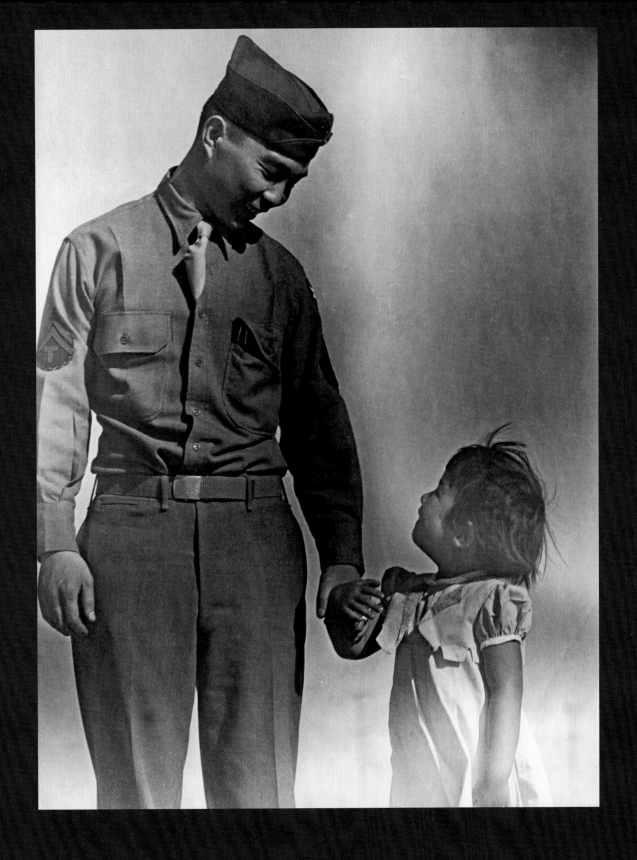

Uncle John is in the United States Army.
He says he is fighting for his country
and for democracy.

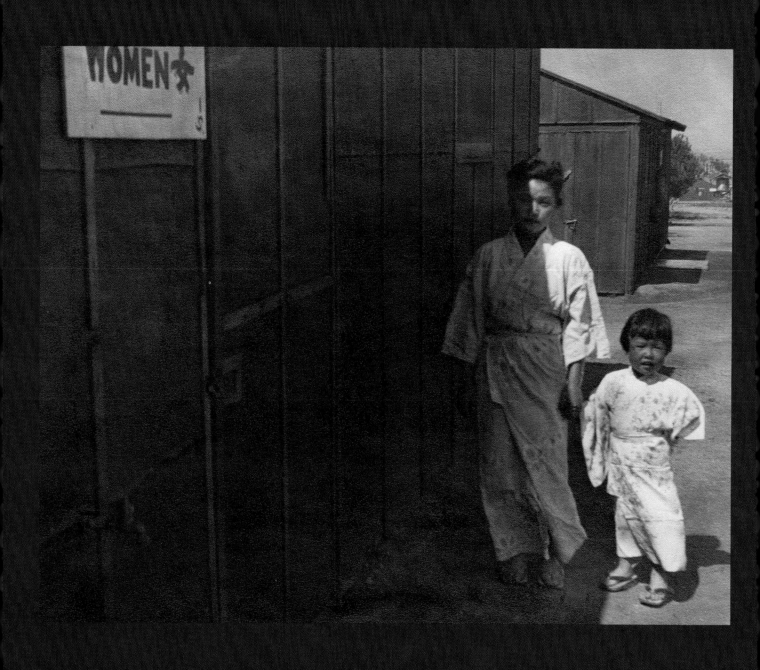

Sometimes at night I have to wee-wee and
I'm afraid to go out in the dark alone, so I have to
wake my mommy and get her to take me to the
bathroom that everybody in the block uses.

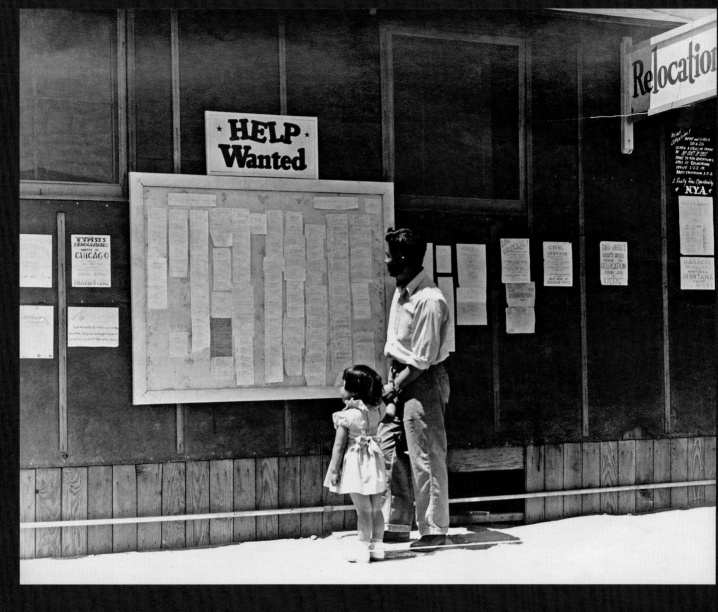

We want to go live in America again.
America needs everybody now.

My house here isn't pretty like my house in Hollywood and there are lots of families living in each barrack. Mommy says it is hard to keep clean. She says if they can put us in here like this, they could put the Negroes or the Chinese or the Mexicans or the Jews or anyone else in too.

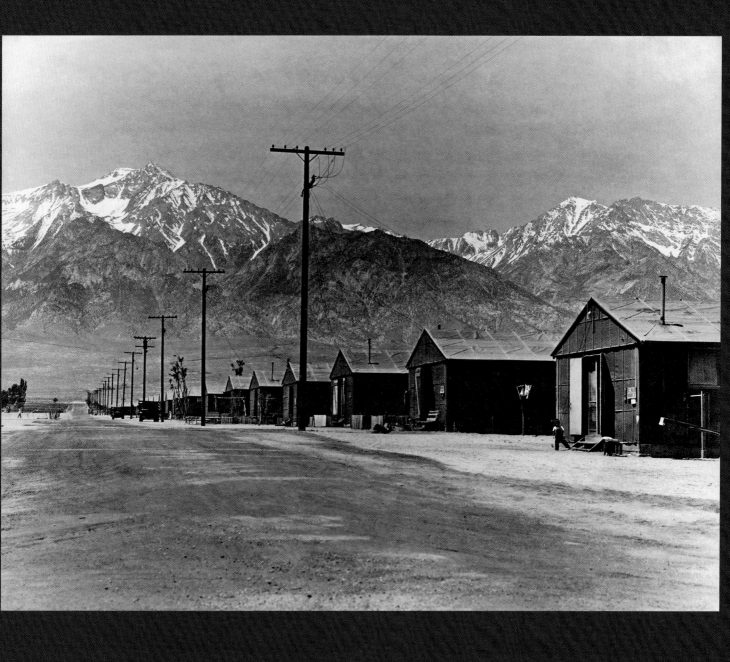

Uncle Paul says he isn't going to join the army even though he doesn't have anyone to take care of. He says they moved him out of his home and they made him lose his job and all his money. They wouldn't draft him like other men because he was a Jap. He says no one loves America more than he does, but he is very disappointed and is losing his faith in America.

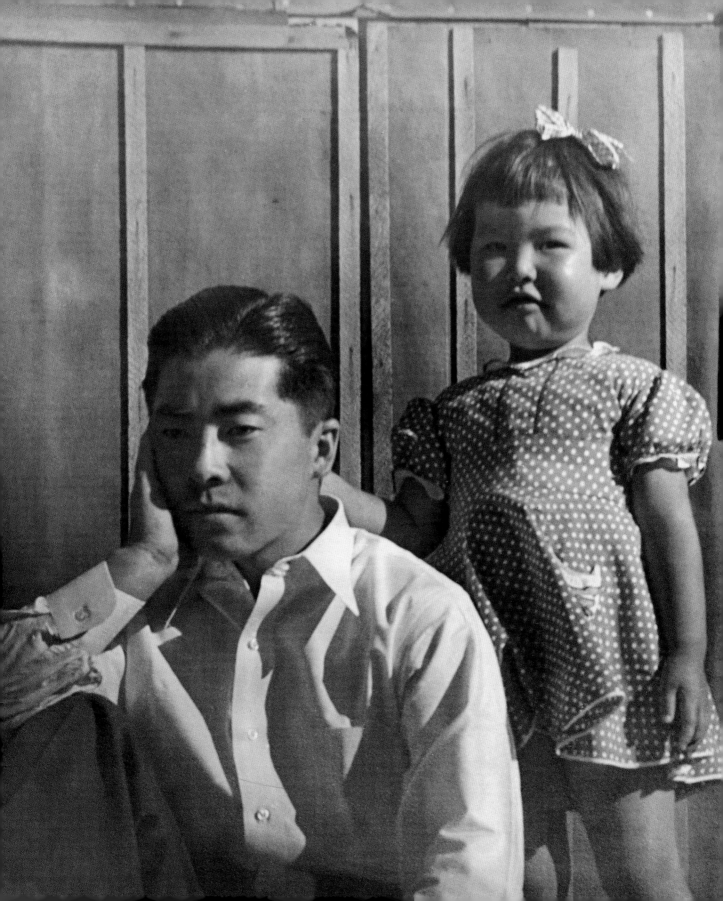

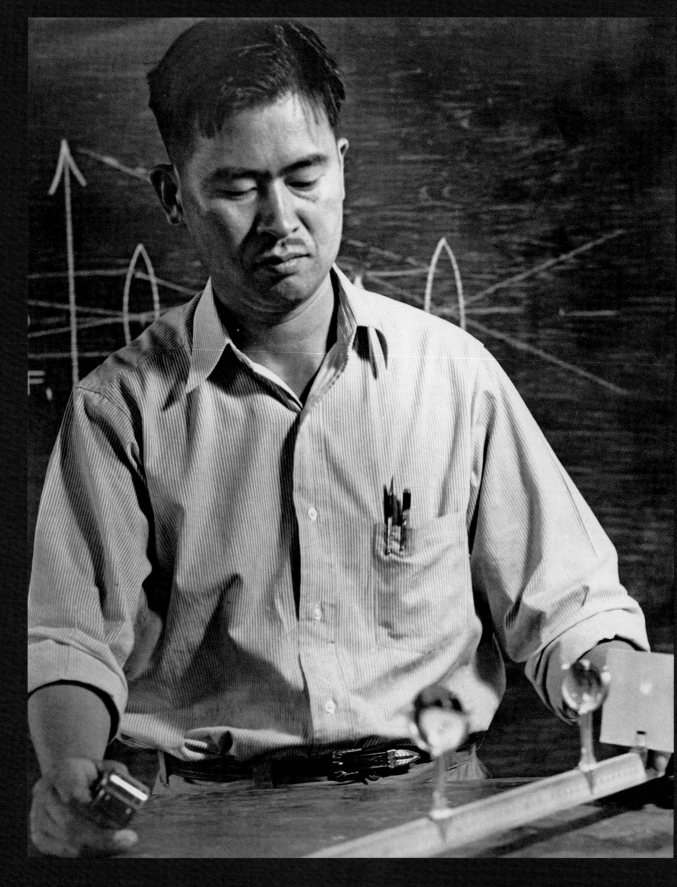

My daddy says he would join the army too but he has a family to look after, so he is a high school teacher for $19.00 a month.

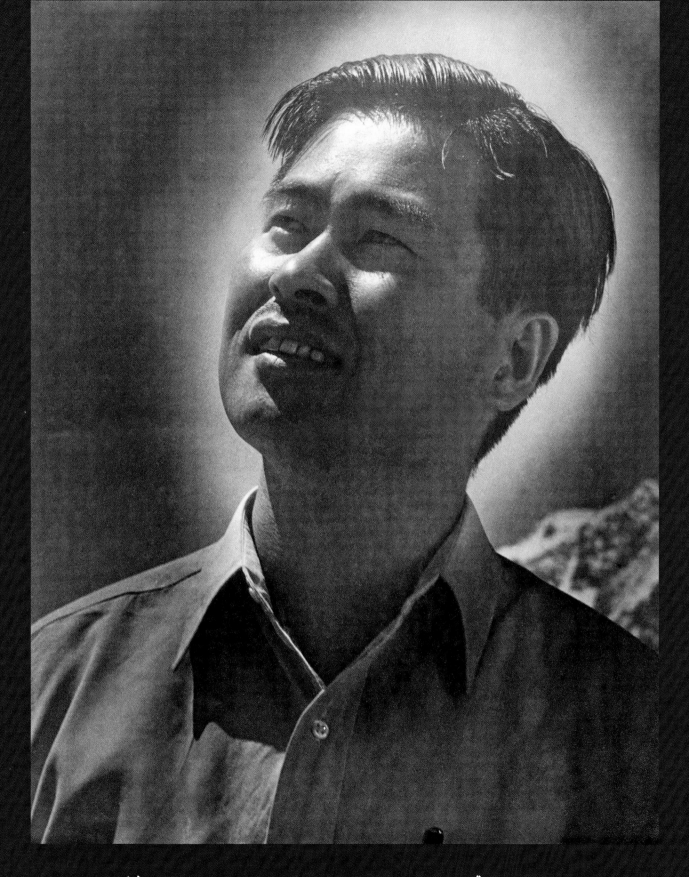

My daddy says he has faith in America
and he knows that the people inside and
outside the centers will do their part.

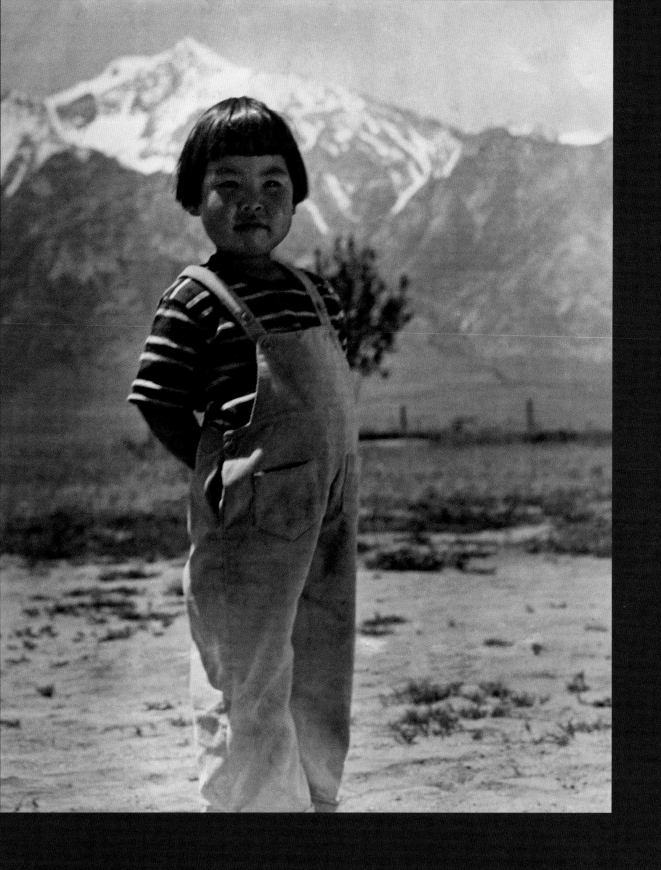

I have faith in America too.

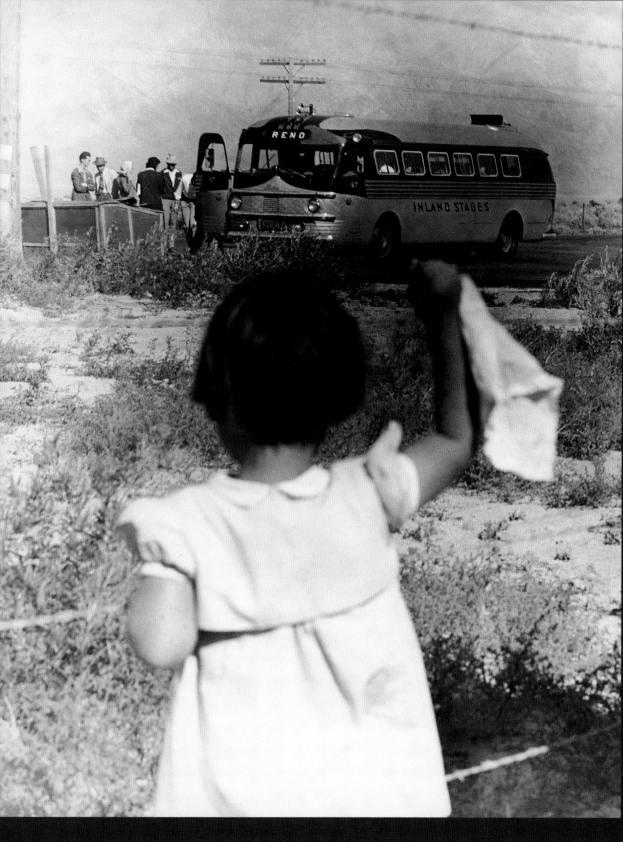

I like to go down to see the bus leave when people go out on relocation. My daddy says most people are afraid to go out because some of the papers talk so badly about us.

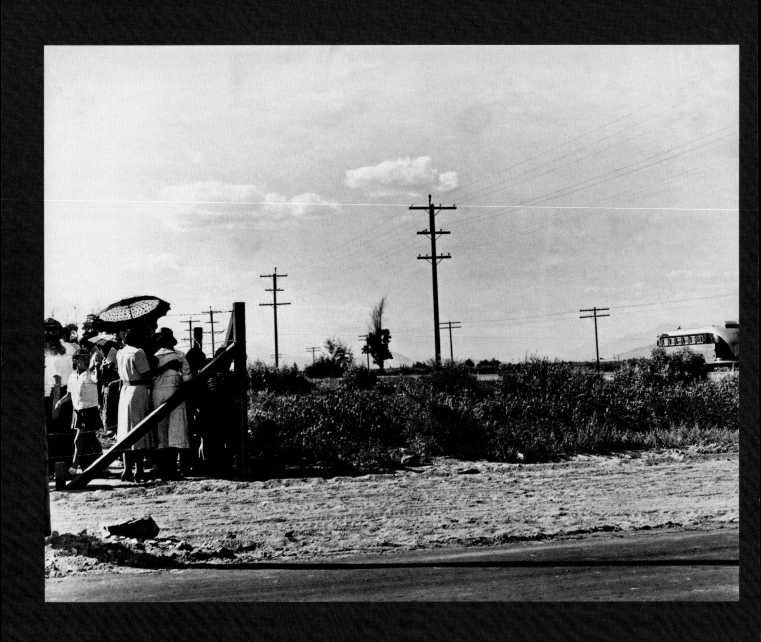

Why can't we come back?
There aren't many of us.

Isn't America still democratic?

AFTERWORD

By Karen L. Ishizuka, Chief Curator, Japanese American National Museum

ALTHOUGH THE UNITED STATES WAS AT WAR WITH ITALY AND GERMANY as well as Japan, it was only Japanese Americans—both permanent residents, who were not allowed to become naturalized citizens, and their American-born children—who were imprisoned en masse without any charge of wrongdoing or due process of law, in what US officials themselves referred to as concentration camps.

Citizen USA takes place in Manzanar, the first of ten such camps that were hurriedly built in isolated deserts, prairies, and swamps in Arkansas, Arizona, California, Colorado, Idaho, Utah, and Wyoming. At Manzanar—surrounded by a barbed-wire fence with eight guard towers equipped with searchlights and manned by armed military police—eventually more than 10,000 Japanese Americans were crowded into 504 tarpapered barracks, each divided into four twenty-by-twenty-foot "apartments" heated by oil-burning stoves and serviced by communal mess halls, latrine/showers, and laundry rooms. In contrast, staff housing was painted, air-conditioned, and had indoor plumbing and refrigerators.

At first glance, *Citizen USA*—which takes on the voice and viewpoint of "Jane Sato," the pint-sized citizen of the book's title, a name that in our research we learned was a pseudonym—appears to be a simple chronicle of a child's life in camp. She introduces herself (she was born in Hollywood, California), her parents ("Mommy was born and raised in Hollywood too"), and her grandparents (they "came to American thirteen years ago"). She reports on the unremitting dust storms that constantly chap her chubby cheeks, waiting in long lines to eat in the mess hall, and having to wake her mother in the middle of the night to accompany her to the communal latrine.

Yet, among these guileless descriptions of daily life are equally forthright yet more insistent revelations of the complex conditions and questionable ethics surrounding the government-imposed confinement. First of all, the title itself—*Citizen USA*—firmly positions the story as an American story, allowing the contradictions of confinement to unfold on its own. For example, Uncle John is depicted as joining the US Army to fight "for his country and democracy," while Uncle Paul won't join, because "he is very disappointed and losing his faith in America." In addition to bringing in such vexing social and political contexts, the little book also imparts the

ineffable wisdom and the abiding innocence of children. As Jane carefully cuts up an apple, her previously exuberant demeanor takes on a serious bearing as she ponders, "We've been treated all right," yet worries, "but what is going to happen to us?"

THE AUTHOR AND COMPASSIONATE ALLY

Some say that children are unaware—too young to be fully cognizant of the reality around them. But Chuck Ferguson knew better. He wrote and hand-crafted this book to emphasize the inhumanity of the camps. In 2002, the original and only copy of the manuscript was donated by his widow, Lois, to the Japanese American National Museum (JANM). I had the pleasure of meeting Lois in 1993 when she donated letters and photographs documenting Chuck and Lois's time in Manzanar. I was enchanted that one of the photographs she donated showed her and Chuck at Merritt Park, the garden at Manzanar that my own grandfather had designed and built during his incarceration there. Lois told me that the photographs in *Citizen USA* were taken by Alan Hennebold, a conscientious objector, who worked at Manzanar as a photographer.

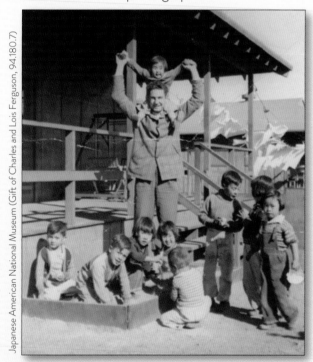

Japanese American National Museum (Gift of Charles and Lois Ferguson, 94.180.7)

Although he taught adults at Manzanar, Chuck Ferguson clearly enjoyed the company of children, as you can tell from this photo of him at the Children's Village, the orphanage at Manzanar. This also documents the sad fact that even orphaned children who had any Japanese ancestry were incarcerated.

In the field of social justice, the idea of being an ally to another person or group has become a key concept in examining issues of oppression and privilege. Being an ally is more than just being sympathetic. An ally is willing to act in support of a targeted group, with the knowledge that all people will benefit from collective efforts to combat injustice. Lois and Chuck Ferguson were allies when the majority of Americans remained silent. When Japanese Americans were abruptly and unjustly incarcerated, Lois and Chuck took jobs teaching at Manzanar. Lois was hired to teach, as she wrote, "the many Japanese college graduates who had not been hired in schools because of racial prejudice," and Chuck set up a night school for adults.

In a letter to friends dated December 29, 1942, Lois wrote with far-reaching insight: "This wholesale evacuation of one minority group has set a dangerous precedent for America which I hope she will never repeat with any other

minority group that happens to be in particular disfavor for some reason or another."

In 1942, Chuck wrote a thesis titled "Political Problems and Activities of Oriental Residents in Los Angeles and Vicinity" for his master's degree in political science at the University of California, Los Angeles, which had brought him into close contact with the Japanese American community. In the foreword to his thesis, he writes, "Now hatred has infected us. Lacking a hereditary foe, we are taking it out now on the alien in our midst." Like Lois, he exhibited prognostic awareness of what would indeed prove to be long-term effects of the mass incarceration:

> Virtually, we invited him [immigrant aliens] with our alluring advertisements of a land where the poorest and humblest had a chance to climb into security and respect. He has the human right to work and live…These proposed policies toward the alien, now so much in fashion among our rapturous haters, are inflicting wounds which may leave permanent scars.

Chuck and Lois left Manzanar in 1943 when Chuck was drafted. Lois went back to teaching elementary school. After the war, Chuck went on to get his doctor of education degree and pioneer the field of organization development, teaching for thirty years at the University of California, Los Angeles, and the University of Southern California. Charles died in 1987, and Lois in 2007; they are survived by three children, nine grandchildren, and ten great-grandchildren.

THE LITTLE CITIZEN USA

So who was this Little Citizen, "Jane Sato," at once innocent and wise?

When Maria Kwong, Director of Retail Enterprises at JANM read a short article called *"Citizen USA: An Unpublished Look Inside Manzanar,"* written by former JANM curator Sojin Kim in the spring 2003 edition of the JANM newsletter, she knew she had to publish the book described in the article one day. We knew that Chuck Ferguson was the author of the book, but what about the young protagonist, "Jane Sato"? Who was she? Where was she? Was Jane Sato even her real name?

JANM staffers Shawn Iwaoka and Jamie Henricks took up the quest with help from staff at the Manzanar National Historic Site. They found no family group that had been imprisoned at Manzanar that matched the names of the characters in the booklet. Taking a clue from the text that indicated Jane's father taught high school in camp, they searched in the Manzanar

High School yearbooks and found an "Albert" Nagashima who resembled the father in the booklet. Cross-checking the Final Accountability Rosters—which recorded every incarceree as they left the ten camps—with National Archives records, they discovered there was an "Elbert" Nagashima who had been in Manzanar, and that he had a daughter, Ruth, who would have been three years old in 1942, the same age as Jane.

Was Ruth the "Jane" they were looking for? After a dogged search using databases and making many phone calls, Shawn and Jamie finally found the Little Citizen. She was Ruth Nagashima Braunstein.

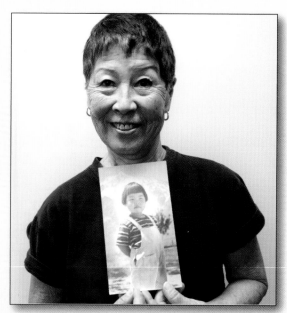

Ruth Nagashima Braunstein

Although her photo appears on nearly every page of *Citizen USA*, Ruth had never seen the booklet until I sent her a digital copy when I started writing this afterword. And having been only three years old, she does not remember the photographs being taken. All Ruth knew of the project was that after the war, her parents were mailed some of the photos that appear in the booklet—but Ruth does not know who sent them nor how the sender knew her parents' address.

There are both similarities and differences between Jane Sato and Ruth Nagashima Braunstein. For example, Ruth's parents' and grandparents' first names are the same as those given as Jane's and the photos are indeed of Ruth's parents and grandparents. Like Jane and her mother, Ruth and her mother were born around the Hollywood area of Los Angeles. But though Ruth did have uncles named John and Paul, their depictions are different. The photo of Uncle John is not of her real uncle. And the photo depicting Uncle Paul in the book was actually a photograph of Ruth's uncle Dan.

I was delighted to discover that Ruth's grandparents and my own knew each other and also that Ruth is related to two notable persons in Japanese American history—an example of how intertwined the Japanese American community is. Ruth's cousin was Monica Sone, who wrote *Nisei Daughter* in 1953—one of the first books on Japanese Americans to be published by a mainstream press—and her uncle was John F. Aiso, the highest-ranking Japanese American in the US Army during World War II and the first Japanese American judge in the continental United States.

As none of the incarcerees were allowed to return to their homes on the West Coast after being released from Manzanar, Ruth and her parents were relocated to New York City where

she grew up and eventually graduated from Pratt Institute in Brooklyn. She enjoyed a varied professional life in the arts, returning to school in her sixties to earn a master's degree in art therapy. Now retired, she broadcasts for Sunsounds radio, a station for the blind and sight impaired, and she has taken up weaving and makes handmade dresses for an orphanage in Cuernavaca, Mexico. She has two children and two grandchildren.

A CAUTIONARY TALE

During the mass incarceration of Japanese Americans that lasted from 1942 to 1946, there were approximately 30,000 elementary-aged children in camp. In 2005, JANM paid tribute to the more than 200 people who taught those children. Among the fifty-three of those teachers JANM found was Lois Ferguson. Then eighty-eight years old, and her memory clouded by a recent stroke, she still remembered the dust, her students, and why she and Chuck went to camp: "We just felt indignant that these people had been displaced and really treated cruelly." When I asked their children, Mike, Trudi, and Joe, they also said their parents simply told them: because it was wrong.

In addition to Chuck's extraordinary compassion for and understanding of children, he displayed an even deeper comprehension of the far-reaching impact the injustice of the World War II mass incarceration would have on our country. Understanding the problem he had described in his master's thesis—that the treatment of the Japanese Americans was "inflicting wounds which may leave permanent scars"—he took the op-portunity and occasion of writing this booklet to warn the nation of the future conse-quences of such policies. In Jane's voice, he cautions, "[Mommy] says if they can put us in here like this they could put the Negroes or the Chinese or the Mexicans or the Jews or anyone else in too." Ominously, the last line of the book asks, "Isn't America still democratic?"

The Japanese American National Museum is the first museum in the United States dedicated to sharing the experience of Americans of Japanese ancestry as an integral part of US history. Through its comprehensive collection of Japanese American objects, images, and documents, as well as its multifaceted exhibitions, educational programs, documentaries, and publications, JANM shares the unique Japanese American story with a national and interna-tional audience.

The mission of the Japanese American National Museum is to promote understanding and appreciation of America's ethnic and cultural diversity.